# INTERIORS

Poetry is a bridge
between our Interior and Exterior
Realms.

Book of Poems, Fragments, Love
Sonnets, Sestinas, and Coronas.

Copyright 2018 Jeanette Sobey. ALL RIGHTS RESERVED. This book contains material protected under International and Federal Copyright Laws and Treaties. Any unauthorized reprint or use of this material is prohibited. No part of this book may be reproduced or transmitted in any form or by any means, electronic or mechanical, including photocopying, recording, or by any information storage and retrieval system, without express written permission from the author/publisher, Jeanette Sobey

## Table of Contents

| | |
|---|---|
| FOREWORD | 1 |
| INTERIORS | 2 |
| STUFF OF DREAMS | 3 |
| SHADOWY FIGURE | 4 |
| MAKE-OVER | 5 |
| SECRET BRUISES | 6 |
| PRINCE OR MASTER | 7 |
| UNFINISHED WORK | 8 |
| LET'S EAT CAKE | 9 |
| MUSIC | 10 |
| I'M GREEN BABE, THO' RIPE | 12 |
| I WISH YOU LOVE | 14 |
| PRISON GUARDS | 16 |
| LOVE'S DISEASE | 19 |
| EROS | 20 |
| LOVE'S TALES | 22 |
| SECRET PLEASURES | 24 |
| ESSENCE OF LIFE | 25 |
| HEAT'S ON | 26 |
| FRENCH KISS | 27 |
| RELEASE THE WOMAN | 29 |
| FLEET-FOOTED SPRITE | 31 |
| FRAGMENTS✡✡✡ | 33 |
| SONNETS | 40 |

SONNET 236: MIDNIGHT'S DREAM .................................. 41

SONNET 237: SMALLEST FLAME .................................... 42

SONNET 238: WILD SCHEMES ....................................... 43

SONNET 239: SEASONS E'ER ......................................... 44

SONNET 240: UNDER THE FLAME TREE ..................... 45

SONNET 241: MY SOUL HURTS ...................................... 46

SONNET 242: DREAMLAND ............................................. 47

SONNET 243: REWRITE .................................................... 48

SONNET 244: LIFE'S PATTERN ........................................ 49

SONNET 245: ASHES ......................................................... 50

SONNET 246: SUPERNAL HEIGHTS .............................. 51

SONNET 247: SUMMER SHADOWS ............................... 52

SONNET 248: TWO GHOSTS OF REGRET .................. 53

SONNET 249: PAGES NE'ER READ ............................... 54

SONNET 250: MIDNIGHT BLUE PORTERS ................. 55

SONNET 251: SHALL LIVE FOR THIS ........................... 56

SONNET 252: TRANSFORM ME ..................................... 57

SONNET 253: POOLS ........................................................ 58

SONNET 254: LOVE WITHERS NOT .............................. 59

SONNET 255: MUSINGS .................................................... 60

SONNET 256: RIDE THE SEAS ........................................ 61

SONNET 257: WHAT DO *YOU* HEAR? ...................... 62

SONNET 258: SWEET ENIGMA ...................................... 63

SONNET259: WILD DIALECT ........................................... 64

SONNET 260: HEAVEN OR HELL ................................... 65

SONNET 261: WAIT FOR ME .................................................. 66
SONNET 262: HEAVENLY HELL ............................................ 67
SONNET 263: VIBRANT STAR ................................................ 68
SONNET 264: COMPATRIOT'S PLIGHT ................................. 69
SONNET 265: NO MEMOIRS ................................................. 70
SONNET 266: BLACKBIRD ..................................................... 71
SONNET 267: FRIENDS OR LOVERS .................................... 72
SONNET 268: IMAGINATION ................................................. 73
SONNET 269: HEAVENLY MEMOIRS ..................................... 74
SESTINAS ............................................................................... 75
SESTINA 270: FLOWER ......................................................... 77
SESTINA 271: PRACTICE THE CRAFT .................................. 79
SESTINA 272: TRUE LOVE .................................................... 81
CORONAS ............................................................................... 83
CORONA 273: SOUTHERN LAND ......................................... 85
CORONA 274: REFLECTIONS ............................................... 90
WANDERINGS ........................................................................ 94
BUSH LOVE ............................................................................ 95
LET ALONE ............................................................................. 97
WHITE GUM TREE .................................................................. 99
Other books & Amazon Link ................................................ 101
ABOUT THE AUTHOR ........................................................... 102

## FOREWORD

I believe that Poetry is a bridge between the private and public worlds that we inhabit.

It's a portal offering direct access into another human being's thoughts and emotions.

I invite you in.

This book is divided into the following six sections—

Interiors
Fragments
Sonnets
Sestinas
Coronas
Wanderings

## INTERIORS

Free-falling and digging down into my soul.

The thoughts and feelings discovered there are released by words.

With this sense of freedom, in this section, I explore non-classical verse formats.

## STUFF OF DREAMS

Unfulfilled desires, swirling like gases

Of distant planets, trapped secretly within

Your failing heart and pale, world-weary soul—

The vibrant colours bursting to be free

To spread their messages; infuse your mind

Wake up your coldest cells; warm your thighs—

Lie still, allow the intrusion, feel it

Permeating, creating, lighting fires

That can't be quelled by logic or reason—

For this is Life; its paradigm basic

Crude in form, but it's still the stuff of Dreams

Magic Puff and Stuff; I've got it in Reams!

## SHADOWY FIGURE

That shadowy figure inside, you hide

Denying existence to one and all

The one not quite acceptable—too loud

Too vulgar, too self-centred. Lips pouting

Like Brigitte, hoping entice surly man.

Strutting the sidewalks with swinging, hot curves

There's no family, no preacher, no teacher

To judge, scald; implore you, morals uphold

How wondrous is freedom in all its forms.

Meanwhile you sit; sedately wrapped in cloak

Hiding flights of fancy; rigid arms, legs—

Until desires' juices ooze out of you

Shadowy figure breaks out! And life's new

## MAKE-OVER

Wish that I might redesign this jewel, Love

Remould it into flawless, precious gem

That never a heart shall suffer Love's pains

And all may launch a raft on sensual seas

Silver waves burning from passions' hot dreams

Lighting fires to warm cold souls; enliven!

Then blow with mighty force, erotic stream

With wild intent unlock all Love's secrets

That nevermore shall sad hearts die alone

For e'er hearts have pined for Love's gentle touch

And so it shall be; 'til last day on Earth—

Oh! Mystic Gods, endow me, allow me

Make-over Love into an Opus Gold

Each particle destined to do no harm

That Lovers may lie in arms, strong and true

## SECRET BRUISES

You have entered my world; disturbed my mind

With words, ways, deliciously unsettling

Awakened me from the longest slumber—

I'm the Woman you cradled back to life

Everything else matters not. I declare

To skies above that Time has not killed all—

I've a secret river, swiftly flowing

Beneath my cool exterior, careless

Words: And I'm ripe and ready: Taste my fruits!—

From the lowest branch to the highest

There's sweet juices oozing from love's desires

Please pick, squeeze; 'til you bruise my heart and soul

## PRINCE OR MASTER

You must understand the changes you've made

Shaking my universe; rocking the ground

The earth split under my feet; scary world—

A thousand cracks between my timid toes

Means I'll ne'er again, stride with careless air;

Now I tremble, waiting for you to come—

Will your eyes speak of love? Or be glass stones

Will your voice be warm? Or cold, indifferent

Take heed of the effects that flow from each—

Select wisely—Sweet Prince or Cold Master?

For *Prince* will always have my red, hot heart

But *Master* know only, cool acquiescence

## UNFINISHED WORK

Oh! How you've invaded me; my being

Made over, but still a work in progress

Unfinished business, acts not completed—

You cannot leave me undone, unfulfilled

Come here! I'm waiting; a ghostly sunrise

Uncoloured, untouched, unloved and dying—

Can you hear the last gasps of passion's breath?

Like sad symphonies destined float in air

Whispered by trees bent low in the winds—

Retouch my sunrise with gold's brilliant hues

Repaint my sunset with your purpled brush

Please! Make me over! Again and again

## LET'S EAT CAKE

How high must I jump? How Far?

I want to leave behind this sorry mix

That has gurgled and curdled

My small, soupy world of stale leftovers

Each day I've ladled, tasted

The acrid bitterness and hopelessness.

Let me remix ingredients—

A firm base of hope, sprinkled with romance

Ephemeral creation

But 'tis better to live in a sweet Dream

All froth, bubble; custard cream

Than drown in a pot of stew

I take a leap, clear the edge!

Now hold me close; let's eat cake together

## MUSIC

Sometimes Music cradles me

Wrapping me within its notes

Rocking me gently to, fro

I sigh, unravel

Memories, Music; Time Travels

Each soul embarks on journey

Unique, private; world hums

I cry, surrender

The Dancer within raptures

Each note and beat incites bliss

Carried away, sprouting wings

I breathe in magic!

Time and time again I'm brought back from brink

Over and over, I taste wild, hot pink

I paint my dark shadows; my woes, hoodwink

Oh Music, play on!

## I'M GREEN BABE, THO' RIPE

You know not, my inner world

Shall never plumb its depths, heights

You hear my words, see my smile

I'm cool babe, not wise

A thousand roads not travelled

Adoring lovers not met

Hands not held and lips not kissed

I'm green babe, tho' ripe

But you don't know, how could you?

My acting skills proficient

I study the craft, learn lines

I'm a distant Star

You can see me from afar

Fragile glass you must not shatter

Lest you release, the dark matter

I'm complex, I'm shy

## I WISH YOU LOVE

I wish you Love, nights, days

You're in my thoughts always

Your face, words, remain e'er—

I'm here, you're there

Love a thousand times dreamed

Is still but a figment

Of my heart, mind, and soul—

I am bereft

May *SHE* come to you, Love

With warm and gentle touch

Closing her lips on yours—

I envy HER

But I hope *SHE* exists

Delights and fulfils you

True Spirit of *your* Dreams—

WE, can ne'er be!

## PRISON GUARDS

Feel the walls closing in

Listen to creaks, moans, groans

As house expands, contracts.

Best to leave all behind

Like bored lover, just quit!

Before it consumes all

For comfort apt to kill

Your wild spirit strangled

Left to languish and die.

Dig deep down; find your strength

Venture out! Demolish!

Break down your barriers!

Leave grey prison behind

Your thoughts—like prison guards

The toughest to o'er come

Controlling your nights, days

No time out to breathe air

In Nature's free garden

Of roses and violets—

You're swallowed by ivy

Climbing in, out, your ears

Your brain's warped and narrowed

Your mind, not blinds, shuttered—

You've a life-force within

Tap and drill and siphon

Drain secret opus well

Change the guards, clear your head

Go boldly, conquer fear—

Your one true enemy.

Raise boot! Kick to the kerb!

Then you'll be free, alive;

Vulnerable, but Victor!

That's the badge of the Brave

## LOVE'S DISEASE

The many faces of Love

We wear as the moods e'er dance

Inside our heads, disturbing

Peace and Quiet, that once did reign;

Now Stormy seas wreak havoc

Upon all reason, muddle minds

How we fight against the tides!

What price, pursuit of passion?

Is wisdom panacea?

To cure all ills, coldest chills

Emanating from desires

Or does it merely suppress?

Excitement, voluptuousness

Killing all, long before death—

Sink or swim, I'll take the seas
Embrace with Joy! Love's Disease

## EROS

Games are on! Twixt you and me

Weaving our stories prettily

Fine tales woven, covering flaws

Guilty truths, have no just cause

To be seen or heard. Banish

All! Like melting snow, vanish

Into cosmos, oblivion

They shall have no dominion.

Sweet-smelling roses we are

Two moonbeams wishing to Star

In a shared, secret romance

You, me, together; Let's Dance!

Slip your tongue in my ear; bite

On lobe, I'll squeal with delight

No more stories please; no tales

Our pleasures are what prevails—

Words will live e'er in our brains—

But lust instils Eros in veins

## LOVE'S TALES

Indefatigable force

This thing, this love, this madness!

Tripping me up, o'er and o'er

Ripping my heart to thin shreds

Beating too fast; All explodes!

I want to dazzle your eyes

With my beauty, with my mind

Astound! Strike you down in awe

Open petals like Spring Rose

Invite you in; delight you

Send your senses e'er insane

As you fulfil me, again

And again. I am your cup

Do make me runneth over

With joy, lust, Eros essence

Oh! We both shall drink and sup

From the nectar, that's life's brew

It was ever thus; Love's Tales

## SECRET PLEASURES

Oh! Spin me out of control

And drive me into madness—

Take me to the brink

I'll scream! Dive head first

Into love's strange land.

Strong urges, hot lips

Curved hips; all demand

Explore the boundaries

Taste-test the climate

Breathe it in and out

Roll luxuriously

Upon Bed of Life

Ready to receive—

And dying to give—

All secret pleasures

## ESSENCE OF LIFE

Let me wake and roll over ♡

Espy the moods in your eyes

The deepest pools of green

I long to drown in.

A vortex giddying e'er

Round my mind, body and heart

Taking down, drawing in

To inner sanctum.

A world wild, luxuriant;

Let your hands roam, discover

New lands; your lips ignite

The flickering flames.

Feel the agony; taste the ecstasy

Fill me o'er and o'er with essence of life

## HEAT'S ON

You bestowed with meaning

My endless days and nights

Split my soul wide open

Sweet Love, Strange God.

From whither do you come?

Pray tell; and why choose me?

My light shines pale, not gold

Damaged Goods, Dull Gems.

Dare I think that brief spark

That glints oft in your eyes

Was lit by me? Can't be!

Oh Me! Oh My!

Have I unsettled you?

Aroused the sleeping beast

Love, within your cold heart
Fate's Struck! Heat's On!

## FRENCH KISS

God! How you drive me Stir Crazy! My Love

My Tease, My Torturer, My Disease—

From which I seek no cure, no recompense

No cool place to lay my hot, burning head

I'm fragile, naked; you're no cooing dove

Piercing gaze, and ignoring my pleas—

Life's kind, mild manners, you do not dispense

Tossing me into world, where my heart bled

And yet, how I do crave it; powerful drug

Substance none can bottle; try catch the wind!

I live each day in hope for one more hit

Tho' it's true, your moods mean I see abyss

Oh! Woe is me; hot fevers; jitterbug!

Dances, Wild Tunes, Romance's mad whirlwind

I burn, I sizzle! I need to cool it!

Before I do; Please! Just one more French Kiss

## RELEASE THE WOMAN

I know this, from cradle to grave, I'll burn

With desires unfulfilled; secret yearnings

Inside, waiting for you to come, touch me

Release the woman I'm longing to be

It's you from afar, that makes my world turn

My days, nights, filled with insightful learnings

Self discoveries of passions, now set free

Languishing, waiting for you; hear my plea

Upend all theories of realities

Toss to the wind! Let them be borne away

We need not their cold, dampening spirits

To drag us down to hell's numbing boredom

Pursue lust; we'll need not analyses

From Freud or peers, indulge romantic play—

I tell you true, it deserves our merits

Come raise me up! Kill depression's whoredom

## FLEET-FOOTED SPRITE

These Moments are all we have; mere glimpses

Of life idyllic; sojourn into Dreams

While other times, we endure wrath of Gods

As they beat upon our backs with fury—

This instant, become aware

Breathe in and out,
taste the air!

If sweet, store in memory bank

If sour; dilute
with wisdom

Store the pearls, most precious gems

Retrieve when needed,
cradle

Futile maintain a register

Of each pain
and treacherous act

Celebrate the essence, nature of life

The fleet-footed sprite is most beautiful

The object of universal hearts and minds

Transient, elusive; worshipped *e'er*, for this

## FRAGMENTS✡✡✡

Poetical Fragments have come to us through—

the Sappho works, medieval and renaissance times, and the modernist, post-modernist period of discontinued texts, mosaics and collages.

Fragments of poetry can arise out of erotic thoughts or insightful reflections about life. They may be found in words that are short, sharp snippets of sexual connotation, or laments about a love that cannot be fulfilled.

The brevity of the scenes created, will contain intense emotions of a moment lived.

Who did inspire the thirst and hunger: lust?
Propel me e'er down and down, slippery slide
'Til point's reached, where Love's danger doth abide
✺

Ineluctable; have to fall in love
With two penetrating, soulful, sad eyes
My passions roused; now unable disguise
✺

You stole the red of my beating heart
Left behind withering, fragile organ
And now, I'm but a ghost, pale, ashen, wan
✺

You live another life; but do not know;
I do, I know; you dwell e'er in my head
The Star of replays of words, you ne'er said
✺

What potion can cure me of this madness?
Wipe memories of you; return the silence—
Let Dreams unfulfilled, cast not, their sadness
✺

I breathed before—saw sky, felt sun on cheek
How can it be, these changes you've made—
'Til I see you, this world's suspended, bleak
✺

Play with your fingers, discover the notes
Become my Maestro, I'll be orchestra
Your cello, violin—Until body floats!
❧

Insatiable, indefatigable, I
My longing for you; Unfathomable depths
An Eve hoping to catch sweet Adam's eye
❧

Before you came, I thought Love was a lie
Sweet-scented roses and sultry hot nights
A sham! But now to see your eyes, I'd die!
❧

You held my gaze; gave way your story's plot
Released my flaming passions from within
So together, let's write script, burning hot
❧

The dry creek bed lay dying for great Love
To come swiftly down upon it and fill
Emptiness; feel passions swirling above
❧

The summer breeze ruffled the leaves and teased
Branches and stems with tickling tenacity
Lingering, 'til tree knew languor; Was pleased
❧

I wander aimlessly through colourless days
While evenings are lit by brilliant nightmares
No matter hues, thinking of you, always
ℯ

Where are you now? Are you happy or sad?
You're like a movie with a tangled plot
At end you'll see; I'm lost reel, you forgot
ℯ

I've written and starred in a thousand scenes
No silent scenarios: wordy, witty
I forget the words—but not your eyes: pity!
ℯ

One night I dreamt myself into *your* world
Upon awakening, my thoughts stayed there
With you, body here, mind there, detached e'er
ℯ

Did you hear my whispers and moans, feel touch
Sylph-like fingers in your erotic mind
'Twas no Dream, I'll come again tonight, primed
ℯ

Oh Dear Love! Thy power invincible!
Sensuous threads that bind can ne'er be cut
I confess, upon Love, I shall e'er glut
ℯ

Cannot erase you from my thoughts and heart
Indelible messages, shot by Love's dart

You reign e'er, Love, in my secret love realm
Master of all, powerful at the helm

I wait, I sigh, I dream, I rise, I fall
Desires unanswered, waiting for your call

Did you not hear me call to you last night?
Laments borne upon the breeze at midnight?

Come to me now; Make me moan with delight
It's twilight; and I languish for thee, Knight

Storms rage; long night ahead; take me to bed
Come! Passions burn hotter, while we're unwed

Oh! Scoop me up and never let me down
For one moment with you, I'm willing to drown

Aromas arouse memories; create worlds
Of mystical bridges, from past to now

Entanglements, man and woman e'er weave
While precious Love, its heart, doth heave

Try as we may, unable reinstate
All those glorious dreams of golden fate

Desires urgent, compelling, directing
Steer my course into a hellish, wild fling

In the midst of flurry, desires, anguish
My sense of reason, logic, doth languish

I declare! World's great literature and art
Come not close, to those dear words from your heart

I could write a literary masterpiece
Theme—my yen for you, incurable disease

Your words light tiny fires upon my skin
Set fire my heart, explode! My head doth spin
◈

From the depths of imminent death's dark vale
Rescue! Your sweet words deliver my bail
◈

If only you knew the power of your words
Deliverance wings from darkness: angel birds
◈

Whisper across the ocean; I'll hear you
The waves pounding, repeating: my heart, too
◈

Tonight I see the moon, but thee the sun
Worlds apart, but love, shall ne'er be, undone
◈

One day I shall look up and see your eyes
Gift transported by breeze: I'll claim my prize!
◈

Your words I carry with me, each night, day
My love, my all, dearest apothecary
◈

## SONNETS

Sonnets about love. Love is powerful, life-changing, and connects us all.

The many practical tasks that we all need to attend to on a daily basis, may cause us to ignore the importance of love at times. However, I believe, it is the timeless and universal concept that impacts all our lives.

Romantic love, comprising wild desires, heart-skipping beats of emotion, and lustful thoughts, is the eternal topic of poetry, film and novels. For true love, the hero is willing to die. The heroine, during her lifetime, may die a thousand deaths, musing about the tragedies of lost love. So too, both hero and heroine, may agonize whether the object of their affection, returns their love.

## SONNET 236: MIDNIGHT'S DREAM

Oh! Let me wander boldly cross your mind
And when I leave, may you e'er ruminate
Upon those hills and vales, you'll surely find
Snow peaks, secret passages; love's sweet fate

Return, my wild explorer, with strong hand
Mind determined to carry out the task
Leave no spot untouched, unloved, it's free-land
I give body, soul; adore life's full flask

May your cup spill o'er with laughter and joy;
For I will come to you in wild, wet Dreams
So rise to occasion; I'll not be coy

Together, we two, shall swim passions' streams
Amidst the flurry of maddest fever
In Midnight's Dream, I'm a true believer

## SONNET 237: SMALLEST FLAME

It's those breathless, quiet moments, I miss you
Looking at Stars, white, cold, unreachable
Light years away and bathed in icy dew
Like frost settling in hearts; lamentable

Who will be the one to reach for the stars?
Attempt to climb formidable mountain
We, together built: our saddest memoirs
Written from a base of neglect, disdain

Sometimes the Sun's long-flaming fingers scorch
Inside my head; I burn brain filaments
Hot urges to reach you, suddenly launch

My brain, body, submit to excitements
I see yonder light and call out your name!—
For Love can e'er be lit, by smallest flame

## SONNET 238: WILD SCHEMES

If I could read your mind, examine text
Would I shiver from pleasure? Breaths escape
My lips in sighs, aroused, wondering what next
You'll write, as fantasy cape, you undrape

But here I am, amidst a library vast
Books upon the shelves, neglected, dusty
Great novels, literary works; my thoughts steadfast.
—Show me *your* works; May they be e'er lusty!

For whether Shakespeare, classic rhyme or not
Beats strong, weak, iambic, or crescendo
I care not! Your love for me, shall besot

Design *your* rhythms to tease and taunt so
Take this weary soul for a ride in Dreams
Willing partner I'll be, to wildest schemes

## SONNET 239: SEASONS E'ER

A walk in early Summer's gentle heat
Tossing away the long Winter Tales read
Under frosty stars, or cold, lonely sheet
Believing Nature's beauties had misled

The gloom had settled upon horizon
Featureless figures did wander, here, there
While closer look revealed strange masks, wizen
Morose and Despair, lurked on stair, in lair

A world I now do leave, as I breathe in
Elixir of warmth and honey, bedazzled
Seduced by sensory delights; Oh! Sweet Sin

A panacea, a road untraveled
I muse; but then recall, the seasons e'er
And voices lost loves, they too, fill the air

# SONNET 240: UNDER THE FLAME TREE

And so it was, and seems it e'er shall be
Thread of life we share, swings wildly to, fro
A web of Dreams fragile, caught by Flame Tree;
Can we e'er alight and bathe in love's glow?

Will I stand hand in hand with you? Staring
Into the eyes of one my soul e'er knew
Two green wildfires replete wisdom, flaring
Spreading, diffusing, melting frosty dew

This Secret Scenario, I repress
Afraid, o'er whelmed by a reality, cold.
But in darkness, I do whisper, confess

I need your love, your touch; So please! Take hold
Wrap me in your strong and loving embrace
Under the Flame Tree, you, me, face to face

# SONNET 241: MY SOUL HURTS

Oh! The long passage of time since you swept
Me into clouds confusion, delightful
Dalliance of bodies and minds, hearts leapt!
Danced crazed beats all night, 'til sun's arrival

And in the morn, your eyes told ancient tales
Of man, woman; passions I'd never seen
Before you came; described loving details
Until *my* secret desires, you did glean

Now in the brilliant sun's first rays, I pine
For those dark, sublime, mysterious times
Please come again, my life is dull, benign

I'll follow you, matching your beats and rhymes
Into world that converts, swiftly subverts;
I give my all to you, 'til my soul hurts

# SONNET 242: DREAMLAND

Before you came, I never learnt Love's Song
My melodies were colourless beats, dull.
Deep down in my heart I pined to belong
To blessed ones in love; their hearts e'er full

Riches replete with fruits of nature's joys
And if tears were wept, were kept, as token
Shining jewels, souls bound together, alloys
Proof of fondness for t' other, not spoken

But now you're here, with sad eyes and lost lips
I too have lost my way—so come hither
May you rediscover, welcoming hips

Deprived bodies might mean we two wither
And tho' our flesh will someday be wasteland
Bodies sated; Souls dwell e'er in Dreamland

## SONNET 243: REWRITE

Oh! Ever do I strive *not* to love you
Daily do I seek enlightenment, wisdom
To change my thoughts, obtain sanity's view
Become strong, able rule my own kingdom

Then I watch Autumn leaves falling from tree
As tree cruelly discards like paper hearts
Throws away, as if longing to be free—
The leaves lay, like life's misdirected darts

Disarray! It's what I feel, when you go—
Panic casts its usual paralysing spell
Freezing all functions, as you strike that blow!

A dastardly scene; I know the script well
Please come again; rewrite and twist the plot
Romance my favourite genre: Shall besot!

## SONNET 244: LIFE'S PATTERN

What is this feeling that suddenly hits me?
Urges racing unharnessed to see you
Atavistic, primaeval, brain feathery—
The eve before was calm, no hint, no clue

But in this moment I look through eyes, mad!
I cannot distinguish 'tween up and down
Instincts compel me, my secrets unclad
Body, mind, succumbing, like deranged clown

Still, I believe that this was meant to be
A powerful connection's been created—
Somewhere someone has issued this decree

Linking of souls has been long awaited
For Love's immune to tyranny of Time
And designs e'er, Life's Pattern, Words, and Rhyme

## SONNET 245: ASHES

If Love has died, then what is left behind?
Ashes of wisdom or bitter regret?
Do hearts still live, hoping their souls will find
An Opus in each dawn and cold sunset?

Or do they curve inwards spiraling down
To edge of precipice, witness abyss
Bodies and minds clothed in greyest of gown
Their eyes blinded and doomed e'er reminisce

'Tis better by far to rake through ashes
Retrieve the gems, shining enlightenment
To light the hearts, ignite with hot flashes

Bereaved grow stronger; achieve betterment
It's then that Love's worth truly discovered
Enrichment in life—in death—gifts uncovered

## SONNET 246: SUPERNAL HEIGHTS

A miracle! You pull me back from brink
Time after time, with just a gentle word
Suddenly roses bloom in wildest pink
And rainbows dance o'er the shining bluebird

Before, my world was dull, so too, mind, heart—
Waiting to hear from you, dear love, frozen
In time; my life like sombre work of art
'Til roused by love, and life's magic again!

I read your words, savour each letter, prize
I'm shaking! But now, full of hope and joy
Raised to supernal heights once more: see your eyes

Burning in soul; image, none can destroy—
While your *words* have heavenly power, without match
*Love* links you and me; e'er doth it attach

# SONNET 247: SUMMER SHADOWS

To reach the heights, immeasurable, great Love
Souls will learn secret; it creates Life's Art
Born out of tears and prayers issued above
Each pain, each cry, integral steps of heart

A journey towards attainment sweet bliss
The deeper the cuts, stronger desires' flame
When all around is dark, we need Love's kiss
Of this the painters paint; writers acclaim

Greatest mystery, unable analyse
For Love has power to bewitch, beguile
And ever shall it taunt and tantalize

Like Summer shadows, lingering awhile
In hearts; your words too, I recall, rewind
For memories of you—all seasons remind

# SONNET 248: TWO GHOSTS OF REGRET

Oh! I could have loved you, but called you friend
Seems neither one of us would dare to bare
Our hearts and souls—favoured discrete 'til end
Desires we hid; our Gods melted in air

Only whispers were spoken that t'other
Would come, declare loving affections, strong
And Gods grew tired of hearts ever fainter
Courage, action, was needed, not sad, Swan Song

If only we'd heeded Nature's Kingdom—
Witnessed beasts prepared to kill, to win mate
With savage, wild encounters; acts random

But we two were foolish; sealed our sad fate
Hiding behind masks—pale, timid and scared
Two Ghosts Regret, wishing Love! They'd declared

# SONNET 249: PAGES NE'ER READ

When neither one will dare risk rejection
The fear permeating each living cell
While bodies, minds, still crave sweet affection
Who will break the silence, speak love, and tell?

Bravely assert that without love, they'll die!
For two lives are like lost pages ne'er read
Undiscovered words, the saddest Goodbye;
Witness tears flow for Love's Dreams that have fled

So let us step forward; loudly proclaim
Me! I love you; You! Say you e'er loved me
These words possess a power to inflame

Speak not in hushed tones; nor turn, try to flee
Love shall ignite! I'll be filled with desires
My heart will be lit by a million fires

# SONNET 250: MIDNIGHT BLUE PORTERS

Sliding like satin stretched upon jeweled sea
Relentless strokes to sweep me far beyond
Love's Dreams; I lay bewitched, unable free
My body and mind, stunned e'er by Love's Wand

It ignites black magic with satanic skill
Across my body, as flames rekindle
Desires o'er and o'er, burning, white-hot thrill
Pray! Take me to the edge; My brain swindle

I'd die to swim with you in wild waters
In the deep, dark, recesses of your mind
So Come! Drown me in those sensory slaughters

Secret pleasures shall delight and e'er bind
Two Midnight Blue Porters in hotel suite
Lost in the rhythms of life's primal beat

## SONNET 251: SHALL LIVE FOR THIS

Across the oceans, borne upon the breeze
And billowing seas, your two eyes appear
Precious gift;Heart skips!Only my soul sees
Transcribes the glints of passion,I hold dear

Since that first day our lives were intertwined
I knew dark romance, we were destined share
And tho' you rule both day and night, my mind
In Midnight Dreams, your eyes, piercingly stare—

I want to stay here with you, in this world
Supine, divine, sipping elixir gold
From your lips, wet, seductively curled

May your eyes emit messages e'er bold
And each night I shall close them with a kiss
Please know,Now and E'er,I shall live for this

## SONNET 252: TRANSFORM ME

I long to sail into Serene Blue Nights
With you at the Helm, steadying
To feel your hands guiding towards Love's Lights
That I shiver at pleasure's readying

The tingles setting fire across my body
As my heart skips and dances midst the flames
I care not my soul may *burn* eternally
Your touch hath roused in me, desires, wild games

Oh! Kiss my throat until I gasp for breath
Of air! And take me to the edge: life's brink
Then fall upon me, rock me, back from death

Forget those shades of grey, paint me Hot Pink
I'll unfurl, gladly surrender to thee
And you, a skilled artist, shall transform me

## SONNET 253: POOLS

Pools of colour changing, verdant, chartreuse
Your eyes of special intrigue, green, unique
Oh! Please, I beg! Release your charm, unloose!
For I'm e'er bedazzled by your mystique

Love God surely bestowed this gift on thee
Decreed that all who gaze into those lights
Be captured; But I've *no* wish to be free
Deep Soul, Ocean's Gem; Dream-Maker, Jewelled
Nights

You look at me and wander through my soul
Your eyes see all; I'm stripped of any guile
But Nights, Days, let me be, your Midnight Stroll

Come! Read my mind; leave me naked in aisle
I'll shiver as you strip, lay bare, my all
Unfurled I'll be; into your arms, I'll fall

# SONNET 254: LOVE WITHERS NOT

A secret flame e'er burns inside my heart
Eternity will never extinguish
The light sustains when life tears all apart
My body, mind, broken, shall not relinquish

I defy the cruel scythe that Time does wield
Waiting to carve each sorrow and sharp pain
Upon me, and I, like sculptor's ice-field
Doomed to grow colder in frost, my heart wan

But desire once wakened will not give in
It fans my internal flame; makes red hot
E'er I burn for you; Here! Touch! Feel my skin!

Love rages, renews, and has its own plot
When all around the world has shrivelled, died
Love withers not, no matter the tears cried

## SONNET 255: MUSINGS

Do we ensure desires shall ne'er shrivel
By denying flesh, refusing succumb?
Shall I entice you e'er, your brain swindle
I, enigma, a tune for you to hum?

My secret words, spaces, you shall not learn
My body will remain a mysterious world
You traverse in dreams; vale and fragile fern
Awaiting your touch, curvaceously curled

Therefore, you'll possess e'er, carnal cravings
It is writ my Love, the die, it is cast!
Apart ever; no intimate weavings—

But if bodies had feasted, we'd need to fast
If on love we'd sated, no appetite passions
We'd be bored, as with last year's dull fashions

## SONNET 256: RIDE THE SEAS

Hold me in your thoughts with love's gentle hands
Tho' far away, you shall direct this play
Complex genre; drama on shifting sands
Fleeting; My fears that all be washed away

Each endearment you extended to me
Be swept away from both our fond memories
So keep me foremost in mind, is my plea
I want to be your source of reveries

My world exists for you, love; you alone
There's a portal open, both day and night
Come! Enter in; I'll lay bare, secret zone

Towards my shores set sail; end my sad plight
And together we'll ride the rough, smooth seas
Up and down the coastlines, with greatest ease

# SONNET 257: WHAT DO *YOU* HEAR?

Oh! Where are you? I thought I heard your voice
Or did magical leaves flying in breeze
Brush gently, the trees, emitting love's noise
A sweet utterance; my heart, it did please

I turned around to see, but you weren't there;
My heart stopped beating and my eyes grew blind
Maybe it's due to time of year; brumaire
When all dissolves in mist, life's undefined

And yet I know it lives inside my head
Has a life of its own—passion for you!
Writes the stories of words I wish you'd said.

What do you hear? Oh God! I wish I knew
Is it my voice? A sultry, loving rhyme
Streaming in your mind, o'er and o'er, sublime?

## SONNET 258: SWEET ENIGMA

Oh! How you puzzle and perplex me so
Wish that I could view the world through your eyes
What dreams would I have to make my world glow?
Would I seek gold, or dream of starry skies?

Perhaps I'd breathe in—deep, red, velvet rose
Awaken senses with pure nature's bliss
Reject bright baubles; scrunch sand through my toes.
Or would I dream of riches, not a kiss?

One moment I know you; next, I do not!
You'll always be to me, life's sweet riddle
Beguiling; my secret fantasy spot

E'er you rouse my senses; I dance to fiddle!
You play with expert fingers, write wild text
I'm spent, I'm lost, I'm weak; My love, what next?

## SONNET259: WILD DIALECT

Never stop this mad masquerade we're on
Or crush me 'tween reality's cold pages
I hate dull tones; a grey gown, shall not don
A lust for life, your love, forever rages

And tho' it tears my heart and soul apart
You surely know; mind, body, it excites
This skill you possess love, it is an art!
Passions turning off, on, like flickering lights

But wish you'd e'er be, my one constant Star
That I might bask in glow and warmth; reflect
Upon your rousing words; strumming guitar—

I'd write tunes, lyrics; wildest dialect
That only lovers true, can understand
Like impassioned plea for t'other's warm hand

## SONNET 260: HEAVEN OR HELL

Even when you go, Love, you still are here
You're in my thoughts and dreams; vital essence
A reason to rise above my black fear
Reassemble, stave off my senescence

You bless me with eternal beauty, youth
Passions' fires, because of you, shall not wane
I feel light, but I'm full-bodied vermouth
So Come! Taste my flavours; do not abstain

Now is not the time adhere rigid rules
Be free, explore; Nature is always raw
Release your inner beast, discover jewels

The gems are here—within my deepest core.
Come dance with me, whether heaven or hell
Together we'll be—so all will be well

# SONNET 261: WAIT FOR ME

Was it you I heard last night, not the breeze?
A hushed tone, a gentle moan, spoke to me
My heart stopped as I listened to gentle pleas
That I should awaken, arise and flee

Abandon all, unloose my chains, and fly!
Across the Midnight's Sky of blue satin
Release my soul! Sing of love upon high
Where poets compose verses in Latin

Tonight I shall come Love, so wait for me
By yon erotic stream, where lovers dream
And bodies tangle; unlock pleasures' key

Hold out your hand and guide me like a beam
Blow kisses into the breeze, I'll swallow
Gasp! Taste your essence—And surely follow

## SONNET 262: HEAVENLY HELL

I'm here, so stay; hide not in some dark place
Beyond my arms and lips; lascivious hips
I implore thee, for I feel no disgrace
That I adore our strange, decadent trips

Into a world of lovers' make believe
With you as Master, and me, willing slave
What strange sensations, pleasures, I conceive
When you are close to me; your body, I crave

Therefore remove it not, nor heart and mind—
Would you cast me down into that cold pit
To never again dance with passions blind?

You have a power to bring joy; Use it!
Encircle me; show me *all* your weaponry
I'll weep not, for your hell is heavenly

## SONNET 263: VIBRANT STAR

I do not understand, I never will
*Why* does my heart leap each time you appear?
My neurons wildly dance; they sense a thrill
Each organ's alive!—they fully cohere

But each dies alone, as you fade from sight
They pine like cold stars in a galaxy bleak
My planet's dark; it grieves e'er for love's light
For you always shine! I *love* your mystique

Pray tell, why are there only four seasons?
What miracle delivered your words to me?
Why should I exist?...I find no reasons

Until I breathe your essence, then I'm free!
All questions answered; no more enigma
Suffice for me you're here; my Vibrant Star

# SONNET 264: COMPATRIOT'S PLIGHT

Bold creatures are we who write and reveal
Spilling forth our inner musings to all
Naked amidst fully clad; life's surreal
Figure of amusement; day at nightfall

Piece of a puzzle left over: no place
To fit, connect; while others merely stare
With cold eyes; life's painting, abstract art face
That sees emotions as superfluous share

But—Should Love strike them down; une grande maladie
And hearts do burn with fever, while pain gnaws
At bones; Souls shall learn life's great tragedy

Beloved rejects them; their love ignores—
*Then* do they read the poet's text at night
Eager learn fellow compatriot's plight

## SONNET 265: NO MEMOIRS

Oh! Why are words of love so hard to find?
Remain hidden in discourse bland, banal
An endless chit-chat by a timid mind
That's too eager from passion, to unsnarl

Is it decreed that all of life be this?
Somewhere written down by an alien God
That ne'er did shed a tear, or taste sweet bliss
Believing affairs of heart, truly odd

And should we ne'er gasp in awe at bright stars?
But keep our heads low to appease the masses
Dull grey figures, possessing no memoirs

For there's *nought* to write of; and life passes
Blankly in glass millpond's upside-down sky
An empty space, as the end draws e'er nigh

## SONNET 266: BLACKBIRD

I believed I'd ne'er seen a peaceful death
Recalling agonies, soon to wither
Until that morn, I spied blackbird in wreath
Of leaves, low branch; heard voice to come hither

This feathered-soul slipped away in the night
It soared upon high into Midnight Dreams
One moment awake, the next to take flight
On astral journey, midst stars and moonbeams

I know now, it's *My Dream*! Let my end be
Cradled by Nature's Spirits, wondrous life
O'er my heart and head, looking down on me

And I shall sing as I'm set free from strife
Sail into sky; shed all my woes: New Star
Feeling empathy for all, from afar

# SONNET 267: FRIENDS OR LOVERS

I call you friend, but my heart beats for lover
Each breath I take, inspired by your mystique
Bewitched, afraid, I shall ne'er recover
I'll play the game; but look—my eyes bespeak

Can you not read the words that there are writ?
Or listen to moans upon sultry breeze
Whispering to your heart and soul; my transmit
Dying to engage; Oh! Hark! Hear my pleas

Catch, ride, sweet zephyr, and land at my door
Look through my window at body, soul, bare
Enter boldly and lie with me on floor

I will show you how much a friend does care
The Days and Nights will meld in heavenly bliss
Come sweet friend and plant upon me, your kiss

## SONNET 268: IMAGINATION

The Worlds that exist in my head and heart
Realms filled with colours bold, shades seduction
I pray linger, no wish from these depart
They shall always be my sweet salvation

My pleasure craft or rescue boat; I sail
Away to tempting shores of lust and life
Day or Night; e'er obsessed by secret tale
That takes away all my trouble and strife

My body and mind; all playing a part
In this reassignment of rapturous bliss
Awakening Imagination's start

Oh Sublime! This truly intimate kiss
This Day, This Night, forever shall it be
All I have to fill this void within me

# SONNET 269: HEAVENLY MEMOIRS

One has to go beyond the fear, regret
For Love is e'er worthwhile and all there is
Eternal flame in the soul, can't forget
When all has turned to dust, remains life's kiss

Its power could raise the fallen, sorrows heal
Gently rock sleeping back to living ways
The numb and crippled once again, will *feel*
We must e'er invite it in, all our days

Dread of pain, rebuffs, must not rule our hearts
The brave shall win fortune, that is life's prize
The thrills, chills—a part of Nature's fine arts.

So taste it all and look through loving eyes
Stand naked! Embrace the sun, moon and stars—
And you will write, the *most heavenly* memoirs

## SESTINAS

The Sestinas are based upon a strict word-ordering basis. Six words chosen are repeated in each stanza in a specific order. (Lexical repetition) The words that end each line of the first stanza are used as line endings in each of the following stanzas, rotated in a set pattern. There are six stanzas of six lines and an envoi of three lines to conclude. Research suggests that the first Sestina was by Arnaut-Daniel, a troubadour of the 12th-century of Provence. However, it is the involvement of Italian poets, Dante, Petrarch and others from that country, in establishing the Sestina form, which led to the Sestina being classified as an Italian verse form.

The theme of love is presented in the Sestinas. Sestina 270–Flower–is about a flower waiting for the bee to come and pollinate. The act is represented as an act of love in this poem. Once pollinated, the flower is transformed and no longer shy. The envoi indicates she is not prepared to wait for *that* bee to come again. She is free! Now she has tasted love, she will open herself to all. The concept is an allegory for a woman's desires, awakened by her first sexual encounter. She now wishes to explore other loves and other partners.

Sestina 271 Practice the Craft, relates a tale of plunging into love and being prepared to accept all the pains. The fears and pains are overridden by powerful desires to proceed to give all and take all. When desires are strongest, a cautionary approach will never do. The tempestuous longings create the path ahead.

Sestina 272 True Love, wanders into the world of romantic, poetic souls. Sometimes the bold, brash and show-it-all culture, that is prevalent in the digital age, seems to give a thumbs-down gesture to earlier romantic times. But perhaps the manner in which these romantic souls acted, that is in a more subtle manner, could also be perceived, arguably, as more erotic. Not everything is served at once, which builds the intensity of desires.

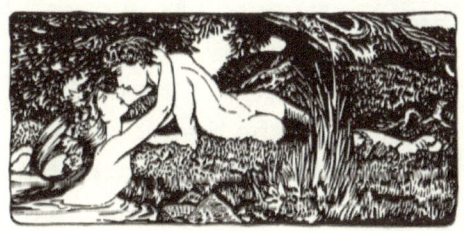

## SESTINA 270: FLOWER

A pale flower dreams nightly of bright beauty
But each morn peers shyly into millpond glass
The pallor she wears like funeral bloom
Her spirit afraid of the harsh dawn's light
Secret Goddess of Love, hides in the dark
Love's passions she craves, but she draws the shades

The love-crazed bee's unable to see: Shades
Hiding sweetest honey, inner beauty
A pure gold delight, but controlled by dark
Inhibitions killing, cutting, like glass.
Which Lover will discover, Truth's light?
Endow gift to other, that love may bloom

Boldly part the petals; let passions bloom
That partners may give, receive, sans the shades
Lay bare the bodies, minds; live in the light
Uncover diamonds, pure, uncut beauty
No mirror could ever reflect in glass
Two souls enlightened; once stripped of the dark

For it's love's nectar brewed, shared in the dark
That transforms the souls, awakens the bloom—
Bee discovering shy flower, will fill glass
Pale flower grow ripe, turn bright; remove shades
A Star will be born out of love's beauty
From now on, flower will long for the light

Tho' bee may flit and flirt; play in light

It spreads magical love-dust into dark
Gives life, a creation: Nature's beauty
Frantic fusion remodels the shy bloom
Made over, no longer she draws the shades—
Disrobes, stands naked, and looks in the glass

Recalls the thrills, hot stings; blushes at glass
Her lover gave meaning to life, shed light
Decadent dance alive without the shades
Flower's passions lit; flames shall light the dark
No longer modest and shy—This wild bloom...
She's set free! Aroused to pleasure's beauty.

Let the bee fly! Taste all shades of beauty—
The flower has blossomed! Love's light, full bloom;
She offers her glass to all, in the dark

# SESTINA 271: PRACTICE THE CRAFT

Your eyes and words wounded me; well-aimed darts
They pierced my soul; I glimpsed at fiery fate
Dreamed not I'd drown in thousands of teardrops
It's these, not the fire; danger to my heart
Sweet words and loving looks, fatal weapons
They're part of love's artillery, dark-craft

For is this love a deadly game of war-craft?
Am I target for you to aim your darts?
Do you revel as you unleash weapons?
Holding the key to my feverish fate
One designed e'er to screw my body, heart
Is your secret dream, my bitter teardrops?

This strange taste upon lips is life's teardrops
A potent potion! Weird, wild witchcraft
And a key twists and turns e'er in my heart
Oh God! How my body bends from the darts
The shocks and blows seem set to seal my fate.
I see eyes glint, as you wield your weapons

Oh what defence have I? And what weapons?
Should I simply savour, all love's teardrops?
To know the sweet, must taste the sour, 'tis fate?
Treasure the gains and pains, make it a craft?
Is life's rich quilt of meanings, imbued by darts?
Should I store wisdom-pearls in my mind, heart?

Come Now! My wild-crazed Warrior, Black-Heart

I await your body, *all* your weapons
Shall bare my body, soul, relish the darts
If I should burn, will be cooled by teardrops
I desire to learn enigmatic craft
I'm open, naked; and tempting my fate

Let us perform amorous dance of fate
The blood shall pump lustily through my heart
Any tears are integral part of craft
Highs, lows, we need to know; taste all weapons—
Let lips and tongues lick the salty teardrops
*Glad* to drown in tears of joy——Gather darts...

Raise your Bow! Aim here, my sweet spot—
Heart's darts
Deliver Fate. I'll swallow love's teardrops
Sweet, sour juices; 'tis craft—
*RELEASE WEAPONS!*

## SESTINA 272: TRUE LOVE

Desires to taste True Love upon one's lips
Steadfast in minds of secret, starry lovers
Look into their eyes, see romantic souls
The blues, mellow-brown, or exotic green
All reflecting deep oceans of passions
They seek to be blessed; bask within love's light

But e'er do they tread bleak desert, no light
No lamp upon a hill, no kisses on lips
Just swirling circles of sand; dying passions
That sting the eyes and hearts, like dead lovers.
Yet still within, the hearts are young, evergreen
Resolute to become bright, shining souls

The world may scorn, deride, those wistful souls
Try delete the poet's text; extinguish light
Scatter cruel words and deeds upon the green
The sneers and jeers issued from snarling lips
Yet they cheer e'er at fake, empty lovers
Digital images, lurid passions

Bold and brash o'er shadow, True Love's passions
Multi-media, sixty-second souls
Enhanced, advanced, quick-fix, guiltless lovers
Flaunting sex and pouting lips, tawdry light
Four-letter words issued from tasteless lips
Kinky, classless, supine, in lurid green...

While unseen, unheard, True Love, hides in green
Pastures of another's dream-field of passions

Enigmatic creature, whispering lips
Speaking words that long to join gentle souls
To proceed with truth's strength towards the light
Dare to dwell e'er in the realm of lovers

And glass is ne'er full for these True Lovers
Cannot lie still and rest upon the green
Intrepid explorers searching for light
To taste lust and e'er indulge in passions
When body and mind renewed, enlightened souls
Shall spread love's messages with unlocked lips—

Witness that special light, playing on lips
Of bodies upon the green; Beauteous Souls—
Endowed with jewels—True Lovers' passions
৵৵৵

# CORONAS

The Coronas comprise seven sonnets and the last line of each sonnet is the first line of the next sonnet. Also, the first line of the first sonnet becomes the last line of the last sonnet. The Corona facilities story-telling. This is due to its length and requirement that all sonnets be linked by a theme.

Corona 273 Southern Land, is about the harsh Australian outback landscape and the wild characters that inhabit it from time to time. Many lines have erotic imagery, for it is the raw energy of nature that is a part of the Australian landscape, that inspires description of it in such a way. The Australian outback has also been the scene of some shocking crimes. Unwary backpackers have become the victims of maniacal, deranged murderers.

However, there are also lines in this Corona, paying homage to the traditional owners of Australia, the aborigines. Their deep connections to the land and their Dreaming Stories are full of wisdom. There is much we, the settlers and descendants, can learn from them. But—will we ever pause, listen and consider? There's a wealth of knowledge to be

gleaned—from the wondrous cave drawings in parts of the country, which are around 60,000 years old, to the management of bushfires and eating bush tucker as a natural medicine. It is acknowledged also, that colonization of the country by European settlers, has resulted in much hardship and losses for the traditional owners.

Corona 274 Reflections—is an exploration of whether art imitates life, or life imitates art. Oscar Wilde in his 1889 essay, *The Decay of Lying—An Observation*, proposed that "Life imitates Art far more than Art imitates Life". I believe that both these events occur, ultimately enriching lives. Both acts are necessary. So too, a shadow, needs both sunlight and a form, to come alive.

## CORONA 273: SOUTHERN LAND

This Land, replete beauty, terror, rich, diverse
The deep southern regions of magic glades
Where ferns quiver, as butterflies traverse—
Their wings brushing against fronds, like fine blades

Teasing desires to feel a more fulsome
Entity; the weight of torrential rain
To fill the heart of a pining bosom
Stop the withering; remove all the pain

The secret forest has been neglected
Sad and alone; it waits for Nature's touch;
Longs for life's rhythms; to be dissected

To spread branches apart and let vines clutch
A vegetation full-bloom, mellow, ripe
The birthplace of love and life; archetype

The birthplace of love and life; archetype
While nearby, racy hills or dulling plains
Lap at edges, reshaping body type
Into a site, compliant, shady lanes

The leaves upon the trees, whisper at night
Orchestrate movements designed for heart-speak
Rubbing against the branch with tiny might
And each stirring's a delicious tweak

While stems aroused in moonlight, seem to dance
Back and forth, as sultry breeze blows a kiss
Ménage à trois, all besotted, in trance

Charmed and tractable; indulged in strange bliss
Until Dawn appears, cool, calm; takes control
And bells shake off the frost; try save a soul

And bells shake off the frost; try save a soul
While northward, palms lean e'er towards the sea
Like tall figures swaying that long to stroll
Across the beach and shelter, alee

And lie down upon the silky, smooth sand
Each grain moist from lapping or crashing waves
Fashioned by Nature's e'er dynamic hand;
From above, Sun looks down at inner caves

Secretions of sweaty desires, latent
Waiting to star e'er in erotic dreams
But rooted to spot, uneasily patient

Then brown, ripened coconut, opens, creams
A sudden burst of glorious release;
Witness multitudes feast; devour a piece

Witness multitudes feast; devour a piece
Tho' far away, red centre, bleaching bones
Are all that's left of those unable to please
Alien Gods or errant madmen, dark clones

Roaming desert, picking up fragile hearts
Beating, ravaging; excited by cries
Of tortured souls, their bodies, raw parts
Butchered and strung up, in the land of flies

Darkest end for the bravest of spirits
Adventurers sturdy of life and limb
Worshipped the world, saw only its merits

At start of journey, full of vigour, vim
Never did dream of evil, cruel beings
Eyes malevolent, and heavy breathings

Eyes malevolent, and heavy breathings.
While others wander blithely unaware
Dancing in moonlight with starry feelings...
Until they're lost and die, as vultures stare

Crows sing mournful hymns, but show no respect
Waiting for chance to dive, to take an eye
Avian marauders, an unholy sect
Show no mercy; e'er watchful, from on high.

But let us heed traditional owners' skill
The first people and land forever tied
Each to the other, with kinship, fulfil

Their stories, the Dreamings; an Astral guide
—Rainbow Serpent awoke; tickled the frogs
Water flowed from the laughter, floated logs

Water flowed from the laughter, floated logs
The stories told to each generation
Word of mouth; voices echo through the fogs
Of time and space; vital conversation

Wish others hearing, looking in, join in!
For sometimes they seem to be, sadly blind!
Blithely unaware, feeling not chagrin
Blissful ignorance is their state of mind

Which one amongst them will dare to listen?
Learn sixty thousand years of deep meanings
And truths; acknowledge history's lesson

Can we come together in the Dreamings?
Enrich our souls and lighten weary paths
Of man, woman, possessed by tiresome wraths

Of man, woman, possessed by tiresome wraths
That split a nation into before—after
Can we now listen to sad aftermaths?
Echoes; Colonialism's cruel laughter

For some believe they're destined e'er to rule
Their way, the only way; manifesto!
Silently applied, a doctrine to fool
For we who do not learn, shall suffer fate's blow!

Stay imprisoned by ignorance; False God!
That encircles, bestows sad apathy
Upon the masses; like evil Ghost Squad

Haunting minds with dullest alchemy
And clouds the eyes; blinds to nature's true verse—
This Land replete beauty, terror, rich, diverse
�às❀

## CORONA 274: REFLECTIONS

Is it sunlight that makes dancing shadows?
Performing upon walls and stone pavements
Or the forms, waiting to strike a new pose
Hoping to star in dramatic events?

And do our works of art imitate life?
Or is it that our lives copy the art?
Wilde's proposal, an anti-mimesis strife?
Or truth's core? I sense a two-way flowchart

For the hearts do long to be set free
With creative expression; opus gold
That souls may rise above the deep, black sea

Authentic flowers; colours bright and bold
And petals perform original dance;
Changes world, like magic wand, shall enhance

Changes world; like magic wand, shall enhance
Eases the depression, untwists the knots
Releases souls to soar, to dream, perchance
Treats pain like swift, sure, adrenalin shots

Awakens to love and beauty, life's core
Enables eyes to see into the soul
Of man, woman, and all creatures of yore
Invites spontaneity; less control

And once discovered, shall never let go
It's a panacea, a magic fix

For cruellest maladies that life may throw—

The Hand of Fate opens its bag of tricks
Selects a piece to make a fatal hit
To take one down, where darkest tales are writ

To take one down, where darkest tales are writ
But if the hand that holds the brush can paint
Strokes imbued with meanings, lives shall be lit
Hearts lifted and the minds clear, reacquaint

Connect once more with love; bathe in its glow;
Bodies be resurrected from wastelands
That were e'er the source of nightmarish woe
And art will warm the wan cheeks and pale hands

Sad souls be free to roam the hills; beyond
The daily constraints, explore other spheres
A realm infinite, wondrous marathon

For beauty resides e'er; allays the fears
And exhuming inner turmoils, gives form
Produces a work of art: a rich platform

Produces a work of art: a rich platform
So too, the words released from deep within
Where dreams and sighs dwell, like latent firestorm
That poet shall rouse with text, tingling skin

And bodies and hearts grow lighter, soar e'er
Towards the light, now freed of dark matter
That had festered and grown in secret lair

Tentacles squeezing hearts, about to shatter

For slowly, surely, the healing begins
Back from the dead-lake frozen, dreams colour
In with bright, bold strokes, decaying skins

Rebirth, Madeover!—rewrites, we favour
Set free by text, shall fly! Talk to angels!
The spirits alive, creation enables

The spirits alive, creation enables
Musicians, composers and dancers know
Performing e'er, richest works and fables
A streaming forth: a fantastical flow

Morose be uplifted, so too, the weary
Lights shining in the tunnels of darkness
Stirring romantic hearts; eyes grow teary
Filled by wonder, a glowing inwardness

Objects, possessions, unable to bring
The joy, rewards, that the Arts provide
So let the World play! Let it dance and sing!

Open the gates of heaven and hell wide
Explore the myths! Face the beauty and beasts
For Arts Creative, are luxurious feasts

For Arts Creative, are luxurious feasts
And Oh! The minds and hearts shall be inspired
With books, music! A thousand dreams released!
Through dancers and artists; hearts shall be fired!

Sad, lonely souls shall wake and view the lives...
See heroines' beauty: strength of heroes
A romantic image in minds now thrives
Like petals, free of thorns, exquisite Rose—

For hope shall shine, glimmer, amidst the gloom
Art's image, text, others now wish to live
Inner feelings of artistes, now full bloom

Out of darkness, words and figures shall live!
Cast of Characters may see souls inspired
Shall dream and hold dearly, *all* that's desired

Shall dream and hold dearly, *all* that's desired
Lives and love are both enriched by art's touch
Events are linked, inextricably wired
Nature's divine intervention is such

Be it art, be it love, be it salvation
No solo dance shall ever be as sweet
Difficult to thrive without creation
Life hums and drums to this essential beat...

I lie on grass, next to wall, and ponder
Neath cloudy skies; grey the wall and barren
But soon, each stone may tell a tale of wonder

If sun shines, I wave, magic doth happen!
—Reciprocity's answer to question posed—
Is it sunlight that makes dancing shadows?
❋❋❋

# WANDERINGS

These few poems are dedicated to the Australian bushland—
The poem, Bush Love, is as the title indicates, about my love of the Australian bush. The many bush hikes that I have taken with small groups of like-minded people, have created this strong connection I now feel for it. Despite potential dangers and hazards of some of nature's flora and fauna, the Australian bushlands possess a wild beauty and occupy a special place in my heart, that no seascape could ever replace.

The second poem, Let Alone, is a plea to people to tread carefully on the land and not to pick, poke and plunder, nature's treasures that exist there.

The final poem in this short series, is about the majestic Australian White Gum Tree. I am deeply in awe of the huge Australian Gum Trees, and it's my belief, that no-one could hope to have a more peaceful and beautiful last-resting place, than under their mighty branches.

## BUSH LOVE

It's here, amidst the eucalyptus scents
I walk, unencumbered by vexing thought
Each step, I leave behind my world; Bush Dense
Under the gum trees; a place I've long sought

What brought me here, I wonder;Oh what Dreams!
Have filled my mind; cravings for wanderlust;
Maybe I've dwelt too long in life's dark streams
I long for light and magical dust

So come, sprinkle upon me; weave your spell
I'll lose myself to sights and sounds of bush
And fall, deeply in love, with each dale and dell.
I know you're waiting, like secret ambush

I'm here at last ! Accost me with delights
Let the birds warble and carol, all sing!
Telling their stories of mating and fights
When they flew to the edge; mad, wildest fling!

The flock soared to heavenly heights, far away
Alighting in strange, mystical lands;
How I envy their freedom and their play
Seizing the moments, dancing on sands

I taste an essence; honey-bush Tucker
Here, where the heat distils its warm, mulled wine
Permeates the body, like life's succour
And quiets the mind with splendour divine

Oh country! Oh Love! I'll be ever true
To you; I'll leave the city far behind
Breathing in your scents and sounds; never blue
I'll be lulled e'er; a languid state of mind

## LET ALONE

My steps begin in a flurry, feet hurry
But then—languor casts its spell, body slows
Obeys my weary mind, burdened by worry
I pause, wonder, at sight of native rose

I know that lovers wish to crumble, crush
To smell intoxicating aromas
That exude from each petal sublime; brush
Cheeks, hands; surrender to nature's comas

Yet greatest gift is e'er to let alone
That other eyes and hearts may too rejoice
Humanity's prize intact; no need atone
For each of us has the power of choice

We may squander and delight in rough play
Lasciviously romping with beauty wild
Take all, indulge, as our lives go astray
The here and now mentality: crazed child

Demanding, myopic, inane affair—
What force can rein in demented urges?
And strip them back to naked truths; lay bare
The consequences. Enact the purges!

Oh! Purify the souls of malcontent
Pare them back to basic needs survival
Endow with wisdom, awareness: Repent's
The doctrine: Reality's Revival—

Softly now, my steps upon fragile earth
My mind's still wrapped within life's heavy thoughts
But cares no longer my own; I rebirth—
It's this land I cry for; danger cavorts

## WHITE GUM TREE

I swallow; breathe you in; a gentle start
The breaths, deep, dark; subliminal passion
Feel love's sweet tingling; arousal of heart
One's country, land, a fatal attraction

Feeling alive, but knowing all must end
When I'll return to my core, and your soil.
As time draws near, my plea—my cares, suspend
Serenade me; let not my soul recoil

For it's still dress rehearsal, not the show
An interval before the grand event
Let me dance, let me sing, watch how I glow!
With short, sharp gasps of passion, I am spent

Applauding each transient season
Marvelling at endless skies, replete white stars;
Why did I not seek before; truth, reason?
Examine planets, moons, their secret scars

It's easy with hindsight blessed, to be wise—
I wish for a rapid restart, recall
Reinvent my body, mind, adopt guise
To fool my heart and soul; Spring become Fall

Turn my world upside down, begin again
Yet what my eyes have witnessed of events
May I treasure; inform my soul; heart's yen—
But I'm on fatal path, despite my vents

—White Gum Tree, I adore your mystical sprawl
Let me lie beneath you when time's at end
That I may hear the magpie's vibrant call
And passing will be a joyous transcend

## Other books & Amazon Link

Emptiness Leers

Pale Hearts

Love's Mourning for Midnight

Sonnets' Whimsical Realities

The Sultry Life of Sonnets

Isadoralola

Amazon Author Page Link—

www.amazon.com/author/jeanettesobey

## ABOUT THE AUTHOR

Jeanette Sobey has a Master of Arts (Writing and Literature) from Deakin University 2014, Melbourne, Australia. She received a High Distinction for her submission of original Sonnets, which formed part of the coursework for this degree.

An Honours Degree of Bachelor of Arts (Communication) special sequences writing and psychology, was completed at Monash University Melbourne, Australia in 2012.

Previously, while working full-time in various administrative roles at universities and businesses, Jeanette studied part-time, and completed a Bachelor of Business at Ballarat University in 1992.

During this time, she also enjoyed acting in community theatre and had a few minor parts in some Australian film and T.V. productions, as well as advertisements. Her love of theatre and performing is life-long. She has participated in local Eisteddfods for Speech and Drama and One-Act Play Competitions throughout Victoria, Australia. Jeanette was always looking for poems and monologue scripts for solo performances. Therefore writing

poetry now, and being able to express *her* thoughts and emotions, is a joy! She finds it to be the ultimate in creative expression. Although she still maintains a passion for creative dance. Formal dance training in various styles, eventually led her to discover the genre of creative dance. "It's a kind of wild meditation for me", she says.

Extra study was carried out to achieve Certificates in Speech and Drama through the syllabus of Trinity College of London, taught locally. This is where time was spent learning about the beats and rhythms of speech patterns, as well as performing.

Later, acting in improvisational theatre, inspired by Stanislavsky method acting techniques, under the direction of Peter Sardi in Melbourne, was an enjoyable period. There was a freedom with this work to explore emotions and impulses with other actors, initially based upon a script. However, the actors were encouraged to go on their own journey, telling a new story, before returning once again to the script. A feeling of authenticity was achieved for the actors, and hopefully too, for the audience.

*¤¤*

www.ingramcontent.com/pod-product-compliance
Lightning Source LLC
Chambersburg PA
CBHW030719220526
45463CB00005B/2116